ROMAN MOSAICS

OVER 60 FULL-COLOR IMAGES FROM THE
4TH THROUGH THE 13TH CENTURIES

JOSEPH WILPERT

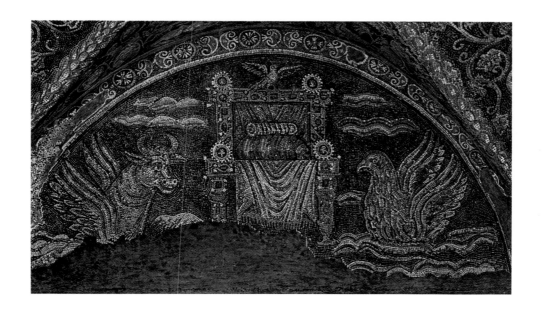

DOVER PUBLICATIONS, INC.
MINEOLA, NEW YORK

Bibliographical Note

This Dover edition, first published in 2007, is a new selection of images from *Die römischen Mosaiken und Malereien der kirchlichen Bauten vom IV. bis XIII. Jahrhundert,* which was published in four volumes by Verlag Herder, Freiburg im Breisgau, in 1916.

Library of Congress Cataloging-in-Publication Data

Wilpert, Josef, 1857–1944.
 [Römischen Mosaiken und Malereien der kirchlichen Bauten vom IV. bis XIII. Jahrhundert. Selections]
 Roman mosaics : over 60 full-color images from the 4th through the 13th centuries / Joseph Wilpert.
 p. cm.
 A selection of images from Die römischen Mosaiken und Malereien der kirchlichen Bauten vom IV.–XIII. Jahrhundert. Freiburg : Herder, 1916.
 ISBN 0-486-45469-X (pbk.)
 1. Mosaics, Roman. I. Title.

NA3770.W52 2007
738.5'20945632—dc22

 2006053474

Manufactured in the United States of America
Dover Publications, Inc., 31 East 2nd Street, Mineola, N.Y. 11501

NOTE

The mosaics featured in this book are all early Christian and originated in various Italian cities, although the vast majority are from Rome. Derived from an influential early work on the subject, *Die römischen Mosaiken und Malereien der kirchlichen Bauten vom IV.–XIII. Jahrhundert* (1916) by Joseph Wilpert, all works shown here may be considered among the most significant examples of the genre. Many of the exhibited mosaics are extant and open to visitors.

Christian mosaic art grew out of Roman pagan practice, which could be decorative or religious. While earlier Roman work prominently featured floor designs (with some wall and vault mosaics appearing in the early centuries A.D.), Christians made the first use of mosaics for large-scale murals, and were also the first to master color effects using glass tesserae (the individual pieces of a mosaic).[1] Glass brought intense color to the art but was better suited for walls than floors because it was more fragile than the marble or stone of prior mosaic styles.

Early mosaics were usually executed on site. In some cases, a layer of plaster was placed over the usual cement base and a drawing was made on the plaster. As the mosaic progressed, the plaster was slowly replaced with tesserae and binding cement. In other cases, a drawing was made directly on the cement.[2] The amount of cement used was significant: too much of it would cause a mosaic to prematurely deteriorate. Placement of individual pieces was important, as much of the beauty of mosaic art is dependent on the proper reflection of light against its respective tesserae—therefore these were carefully placed, usually tilted at an angle depending on the amount of available light.[3]

Over the course of time, Christian mosaics developed an iconography deeply integrated with the religious architecture on which they were mounted. For example, cupolas tended to show images of Christ or the cross; in apses, the dominant trend was to show standing figures of Christ, the apostles, and venerated saints; triumphal arches were often used for apocalyptic images; and scenes from the Old and New Testaments appeared on nave walls.[4]

[1]Anthony, Edgar Waterman, *A History of Mosaics,* (Boston: Porter Sargent, 1935), p. 40.
[2]Anthony, p. 43.
[3]Anthony, p. 39.
[4]Catherine Harding: "Mosaic, Early Christian and Byzantine," Grove Art Online. Oxford University Press, 01/09/07, http://www.groveart.com.

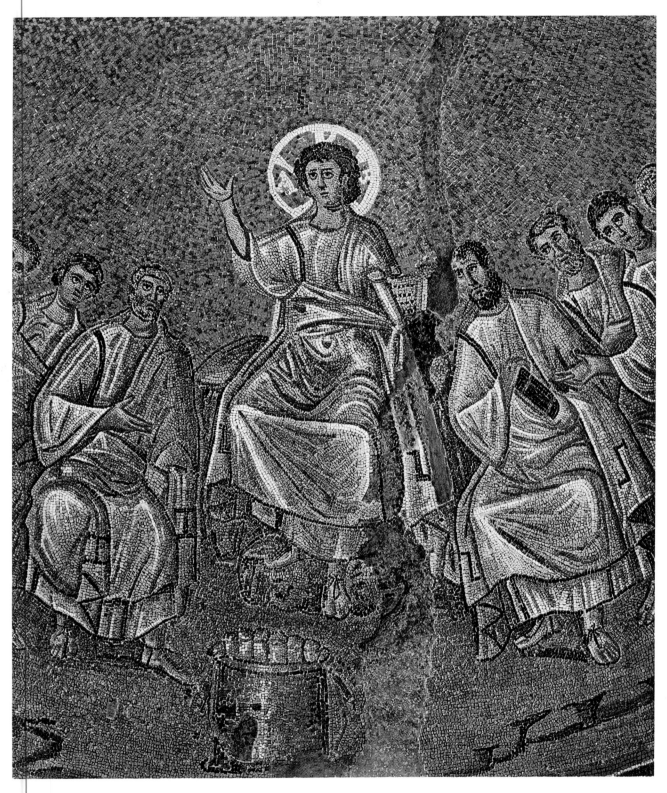

1. S Aquilino, Milan
Christ among the Apostles

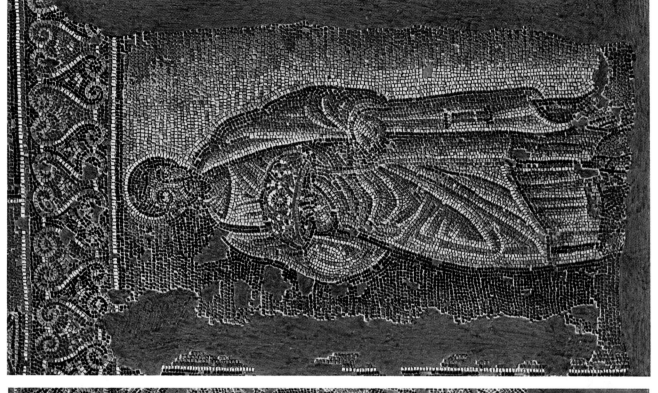

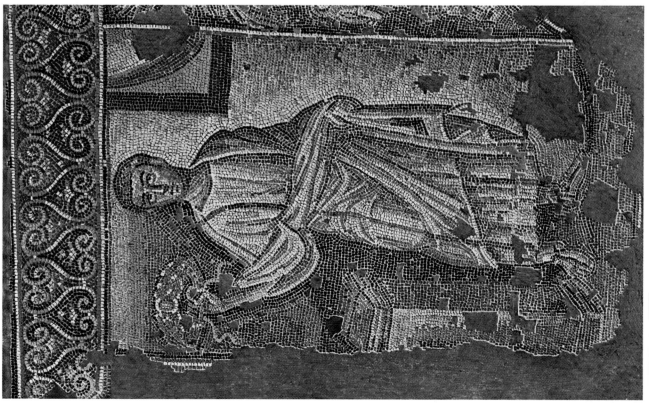

2. BAPTISTERY OF S GIOVANNI IN FONTE, NAPLES
Apostles with wreaths

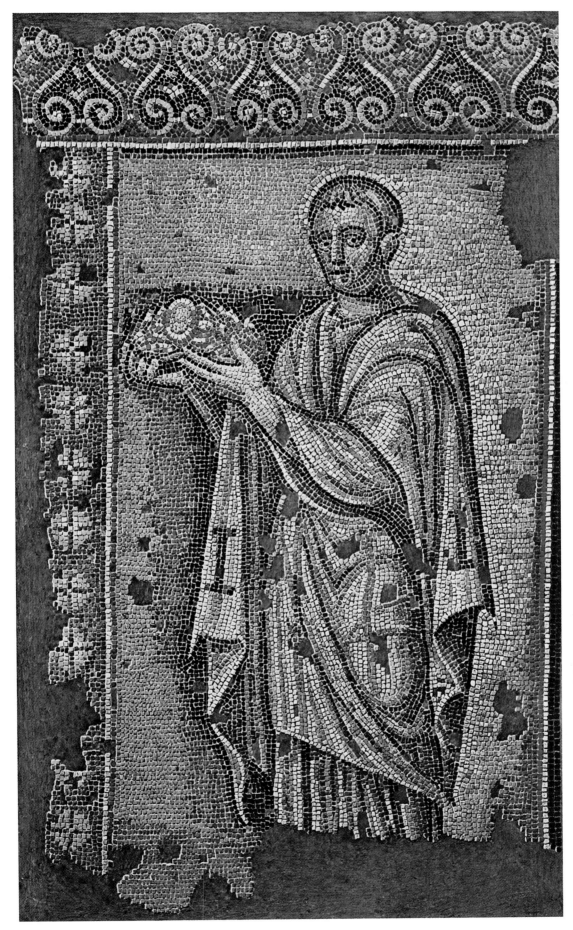

3. BAPTISTERY OF S GIOVANNI IN FONTE, NAPLES
Apostle with wreath

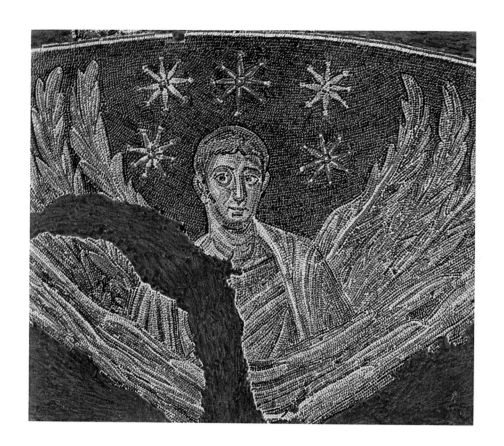

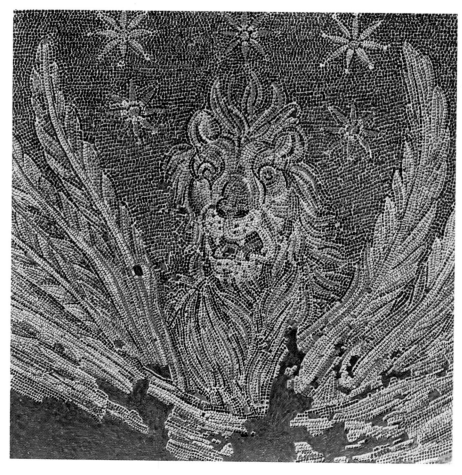

4. BAPTISTERY OF S GIOVANNI IN FONTE, NAPLES
Apocalyptic figures: human, lion

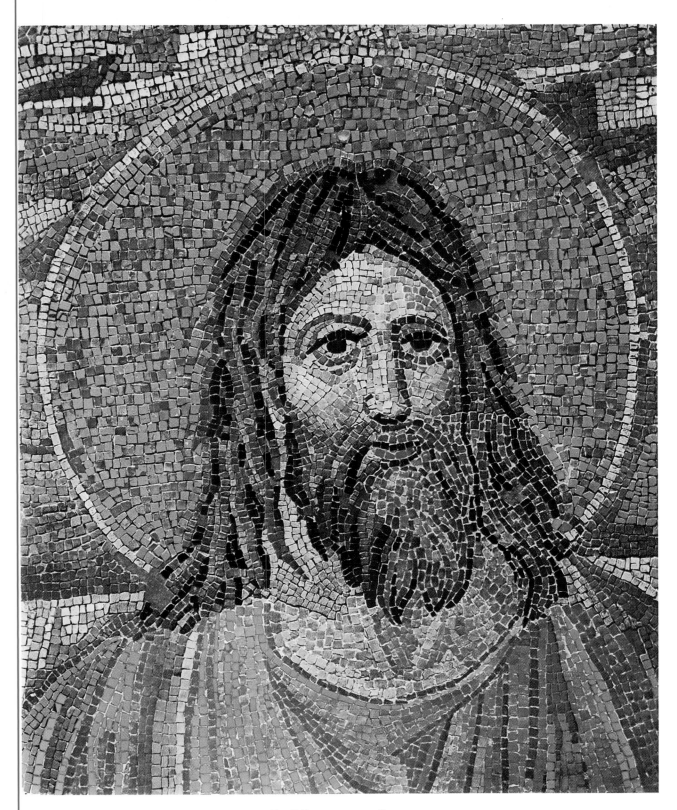

5. S PUDENZIANA, ROME
Head of Christ (detail)

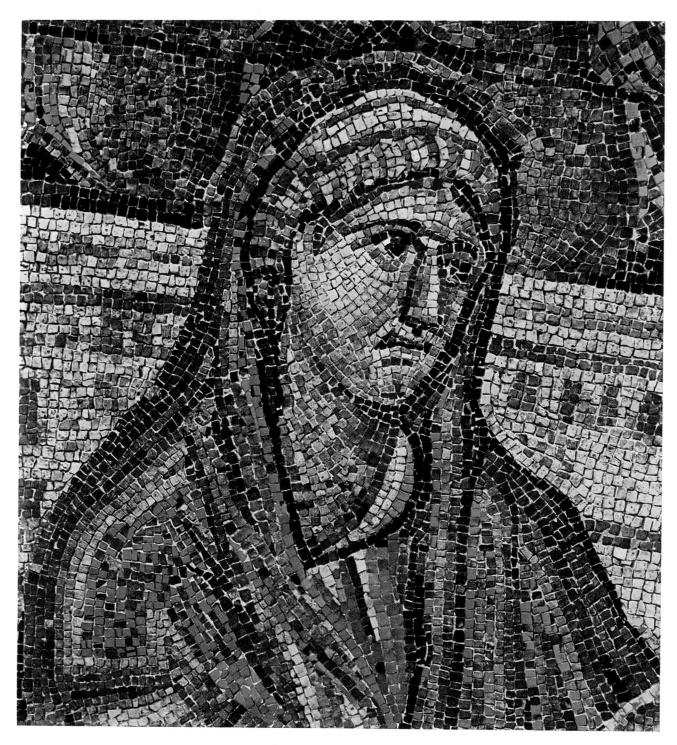

6. S Pudenziana, Rome
Church of the Gentiles (personification; detail)

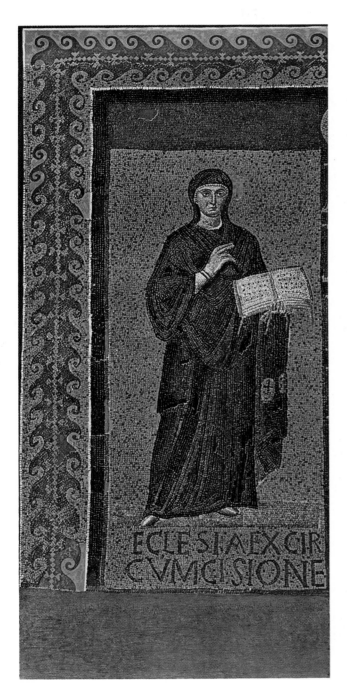
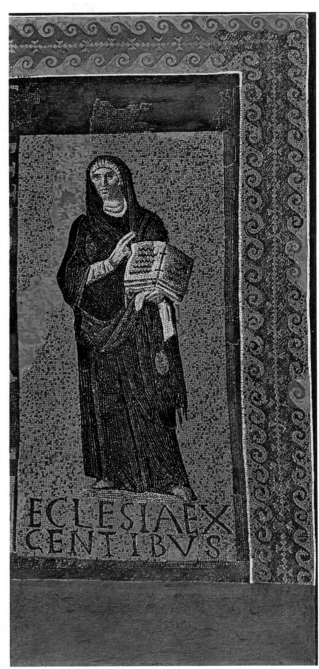

7. S SABINA, ROME
Church of the Gentiles (personification)
Church of the Jews (personification)

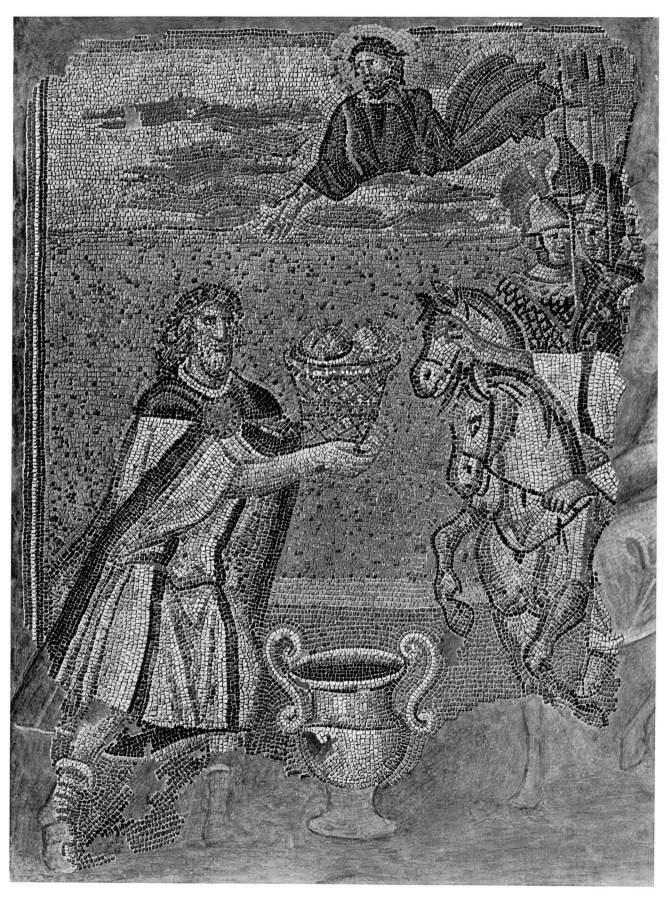

8. S Maria Maggiore, Rome
Abraham and Melchizedek

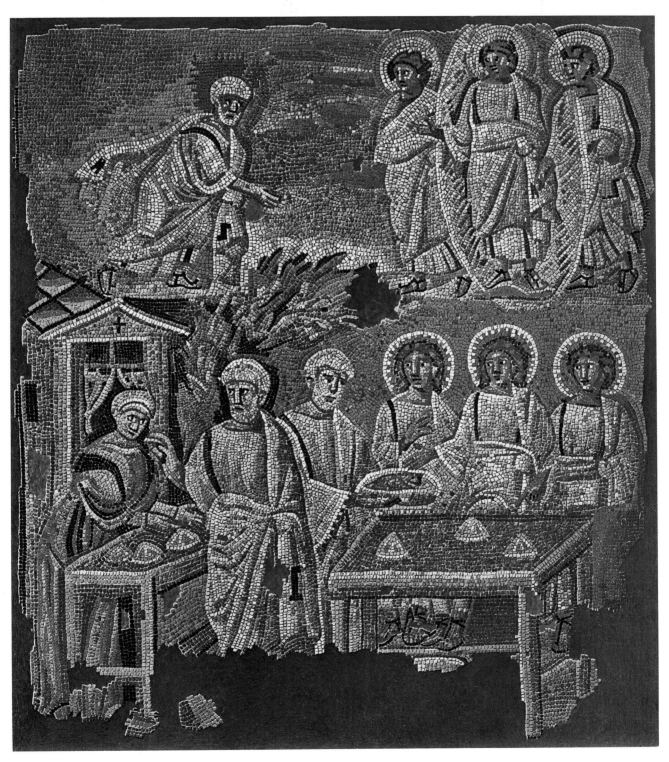

9. S Maria Maggiore, Rome

Abraham and angels at Mamre; Abraham has Sarah prepare food, then offers it to the angels

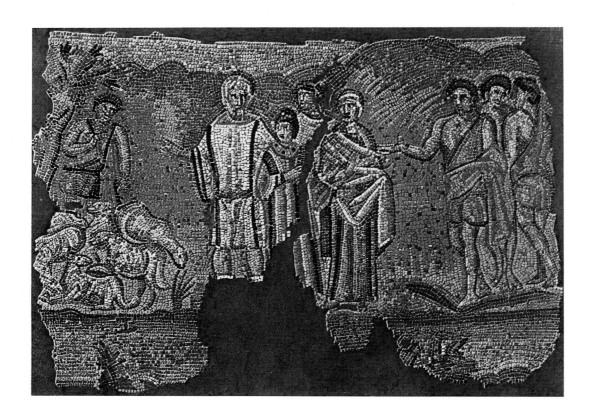

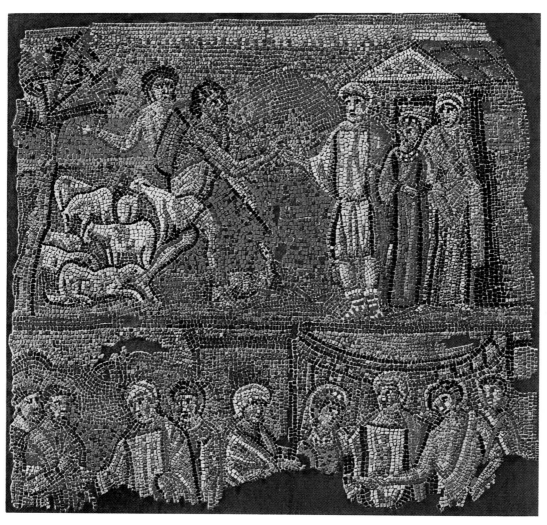

10. S MARIA MAGGIORE, ROME
Jacob asks about Rachel; Laban invites Jacob to wed; Jacob argues with Laban; Jacob marries Rachel

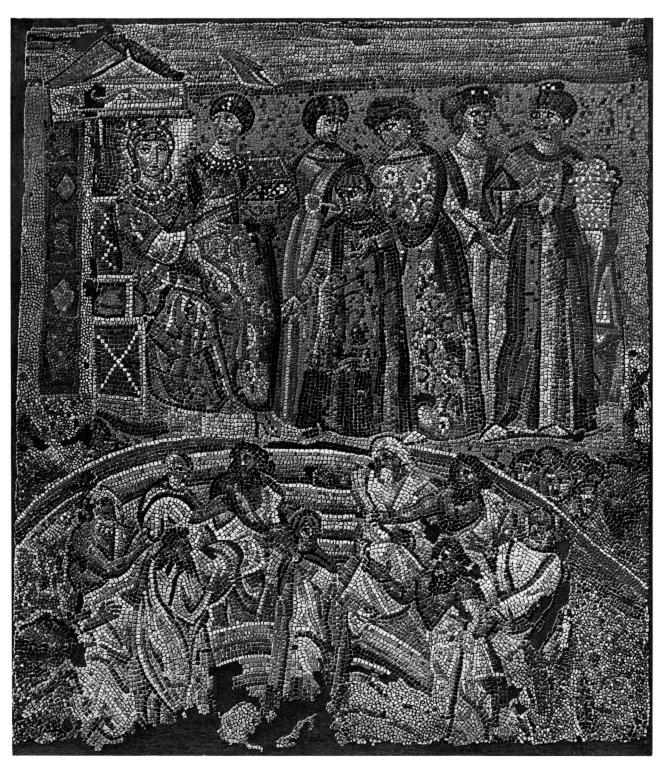

11. S MARIA MAGGIORE, ROME
Moses is returned to the Pharaoh's daughter; Moses debates with the Egyptian wise men

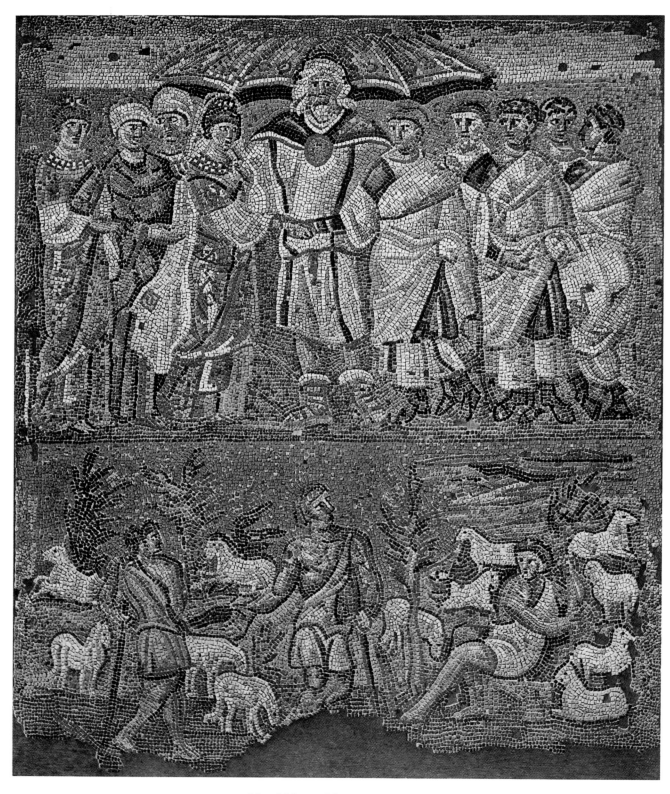

12. S MARIA MAGGIORE, ROME
Moses marries Sephora; Moses and the burning bush

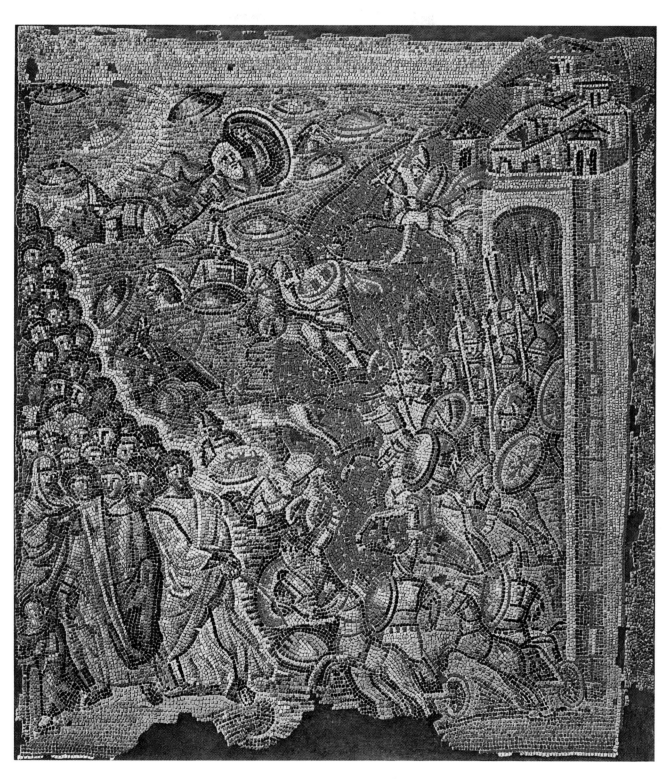

13. S Maria Maggiore, Rome
Pharaoh's army drowns in the Red Sea

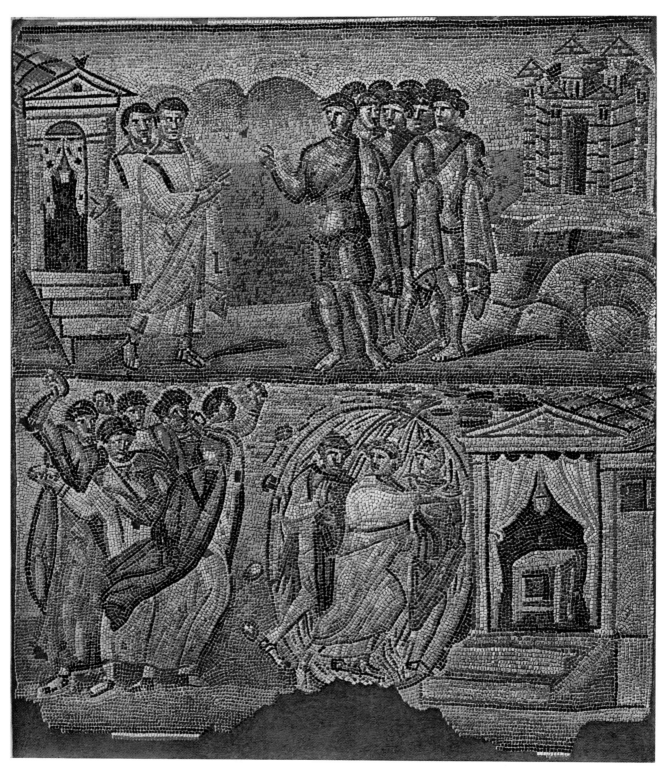

14. S MARIA MAGGIORE, ROME
The spy reports on Canaan; the thwarted stoning of Moses, Joshua, and Caleb

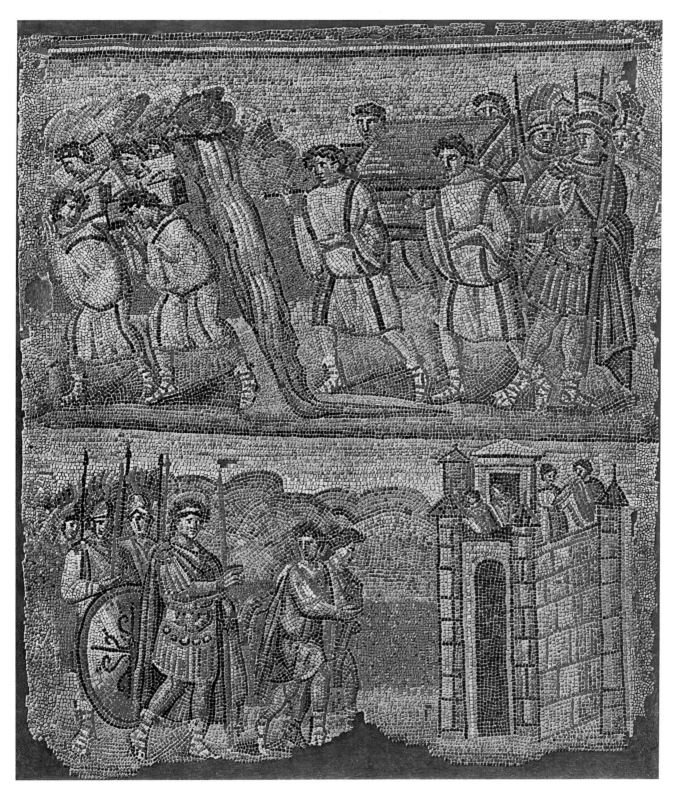

15. S Maria Maggiore, Rome
Crossing through the Jordan, Joshua sends out spies; the spies in Jericho

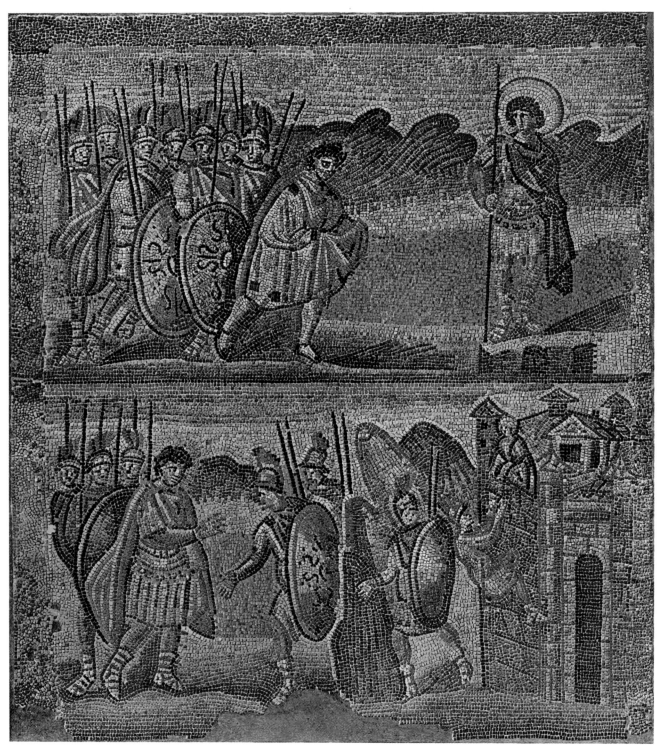

16. S Maria Maggiore, Rome
Joshua before the Captain of the Host of the Lord; the spies flee Jericho and report to Joshua

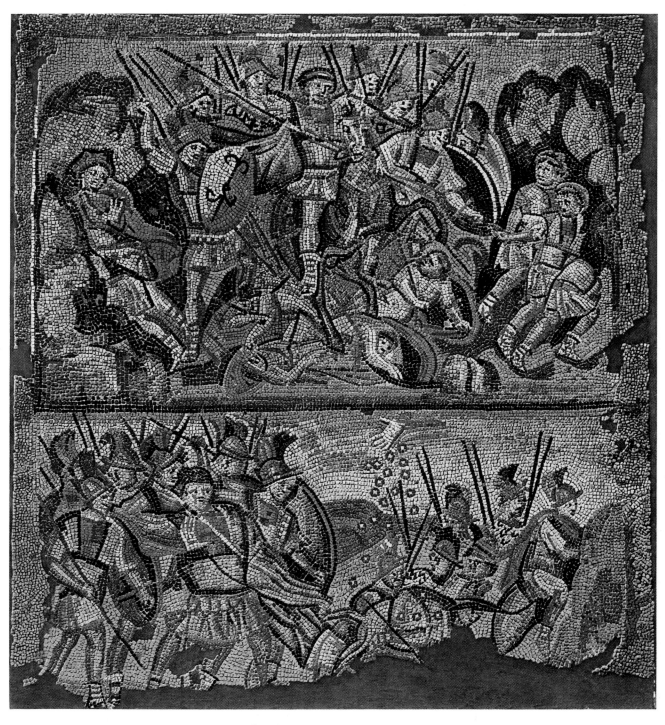

17. S Maria Maggiore, Rome
The first attack on the Amorites; the Lord rains stones on the fleeing Amorites

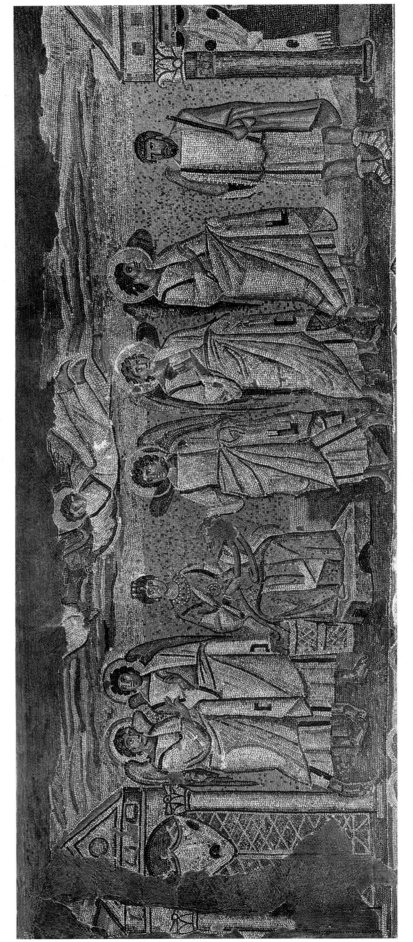

18. S Maria Maggiore, Rome
Annunciation; clearing Joseph's doubt

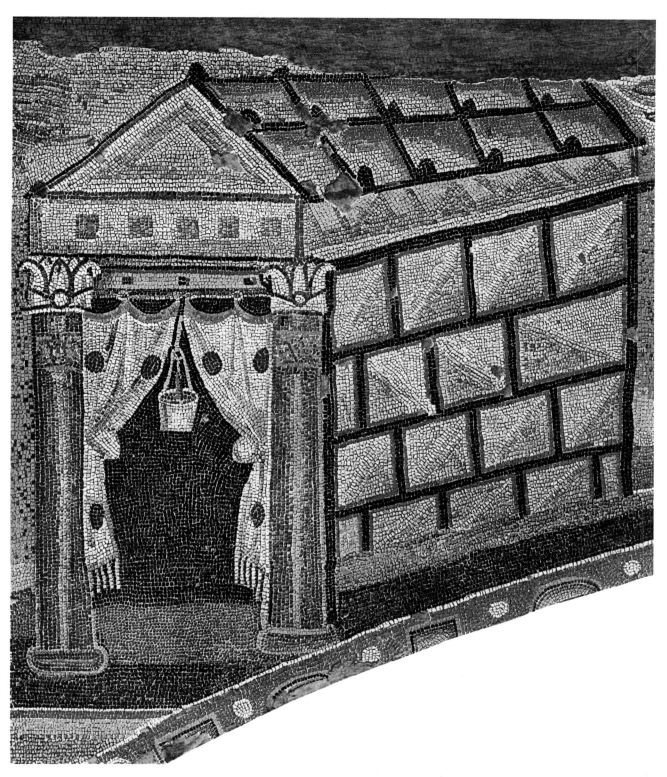

19. S Maria Maggiore, Rome
Joseph's house

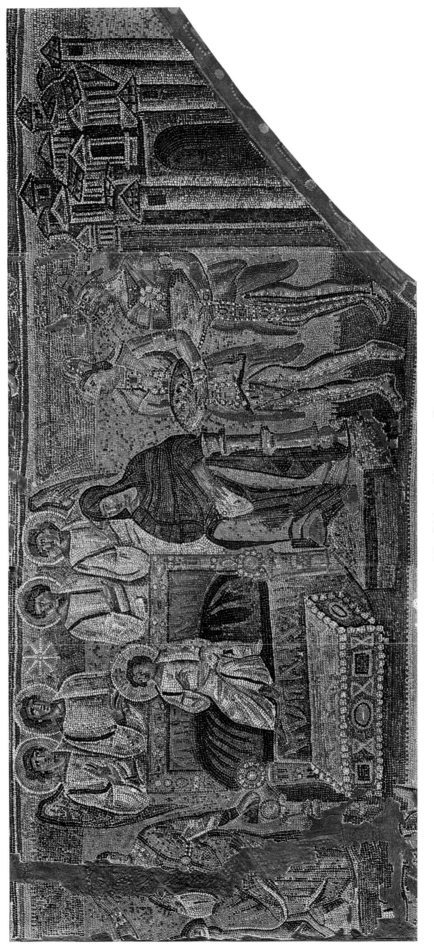

20. S Maria Maggiore, Rome
Adoration of the Magi

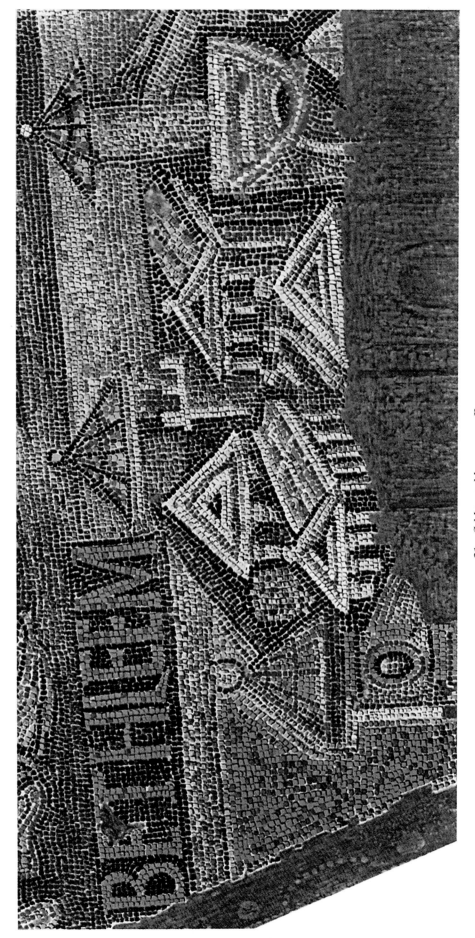

21. S Maria Maggiore, Rome

Fragment of Bethlehem (as symbol of the Church of the Gentiles)

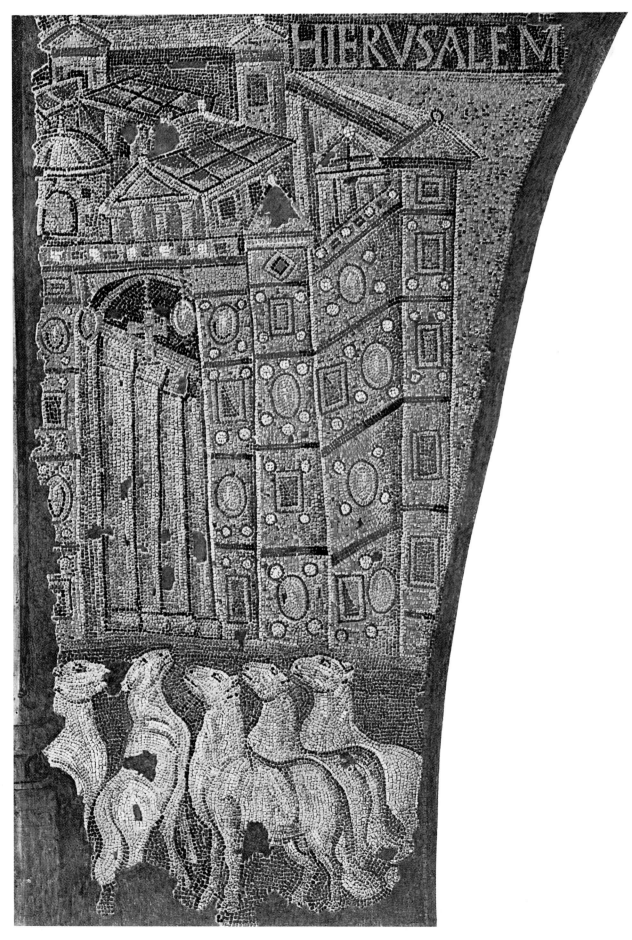

22. S Maria Maggiore, Rome
Jerusalem (sheep as symbols of the Church of the Jews)

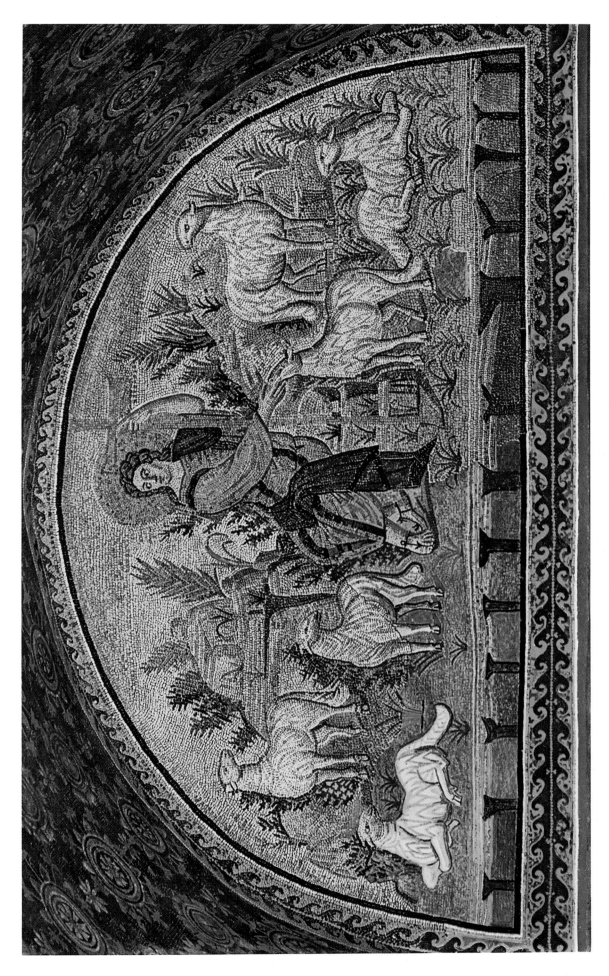

23. MAUSOLEUM OF GALLA PLACIDA, RAVENNA
Good Shepherd with sheep

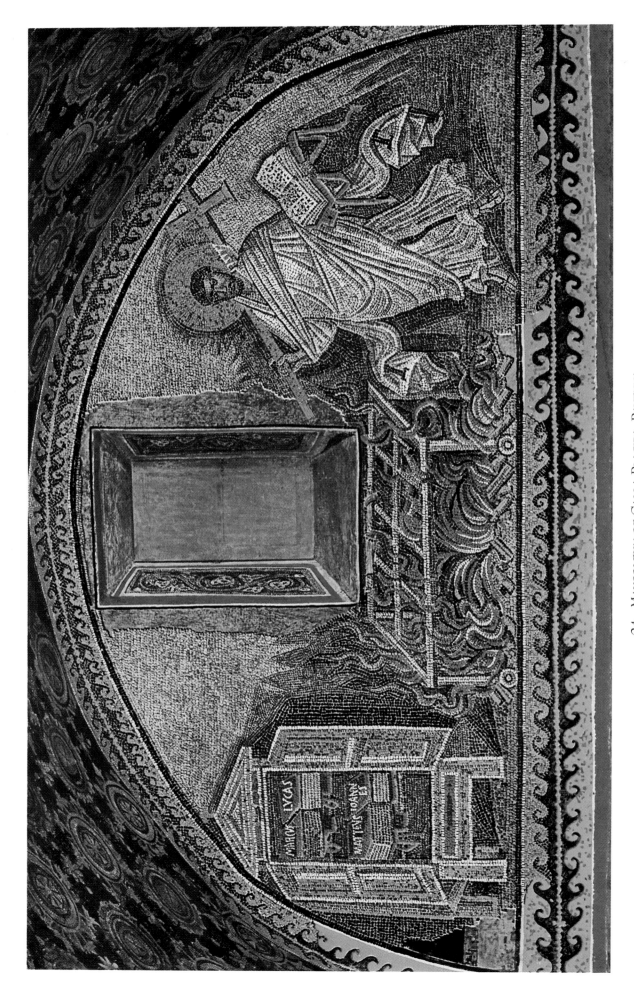

24. MAUSOLEUM OF GALLA PLACIDA, RAVENNA
Martyrdom of St. Lawrence

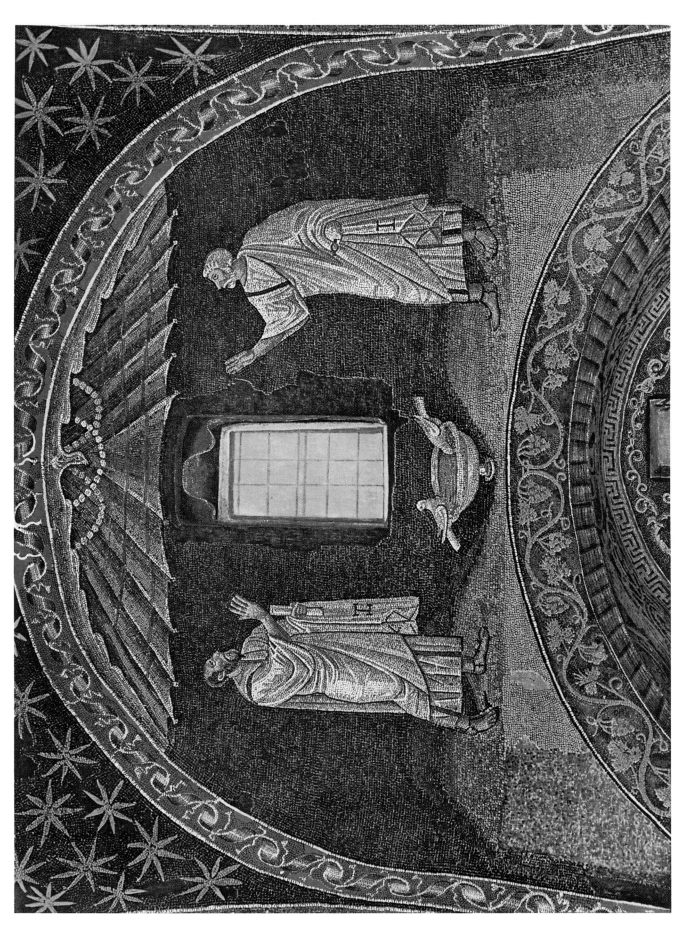

25. Mausoleum of Galla Placida, Ravenna
Peter and Paul, vessel with doves

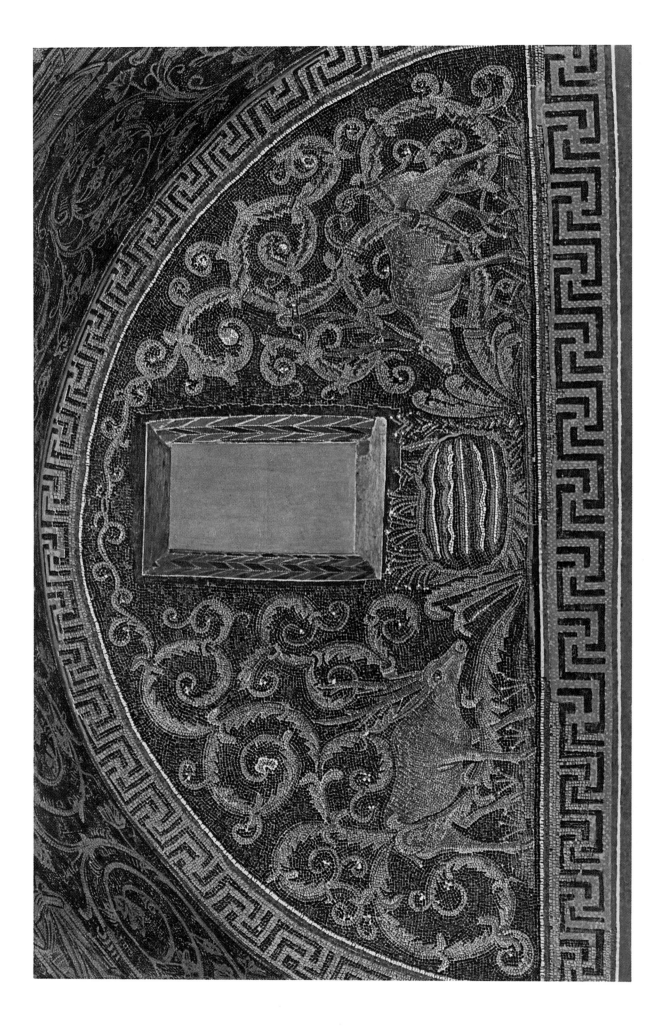

26. MAUSOLEUM OF GALLA PLACIDA, RAVENNA
Harts at the fountain of life (among vines)

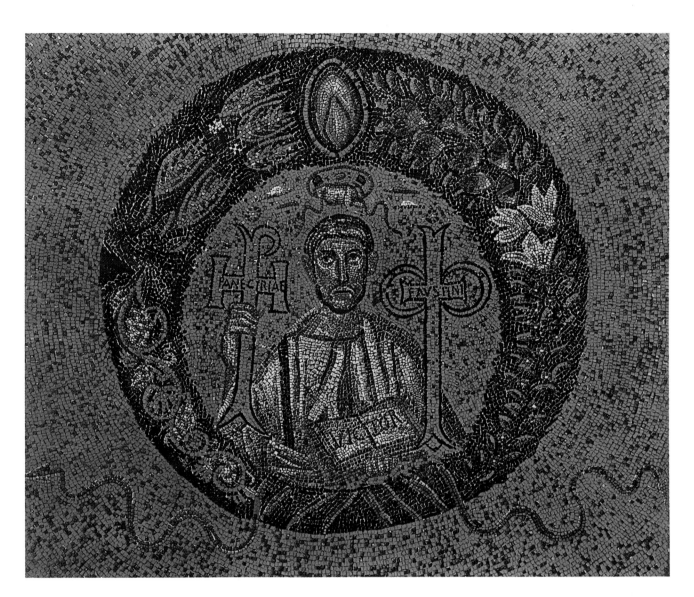

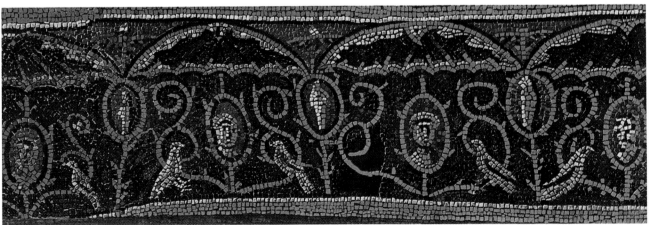

27. S Ambrogio, S Vittorio in Ciel d'Oro, Milan
Saint Victor and the hand of God in wreath of the seasons (ceiling); wall frieze

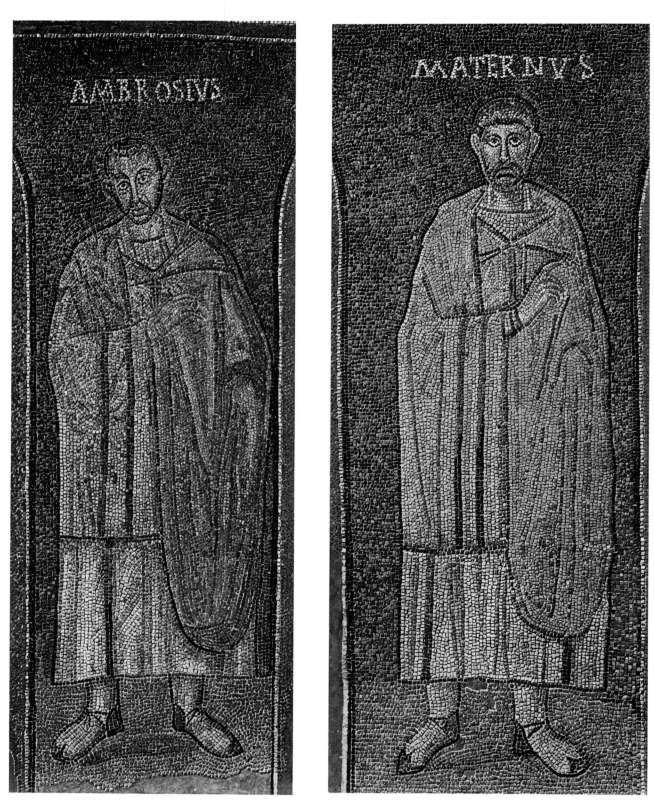

28. S Ambrogio, S Vittorio in Ciel d'Oro, Milan
Saint Ambrose and Saint Maternus

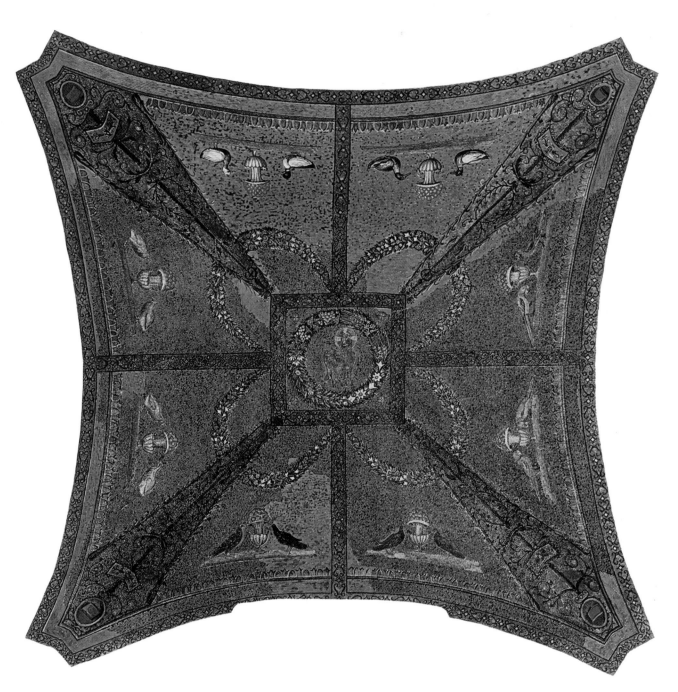

29. BAPTISTERY, S GIOVANNI IN LATERANO, ROME
Lamb of God in seasonal wreath (ceiling)

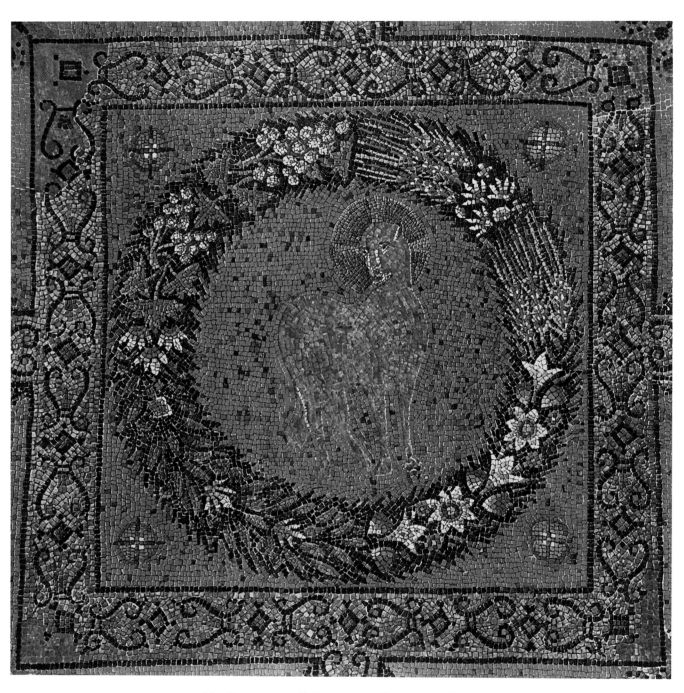

30. BAPTISTERY, S GIOVANNI IN LATERANO, ROME
Lamb of God (detail from Plate 29)

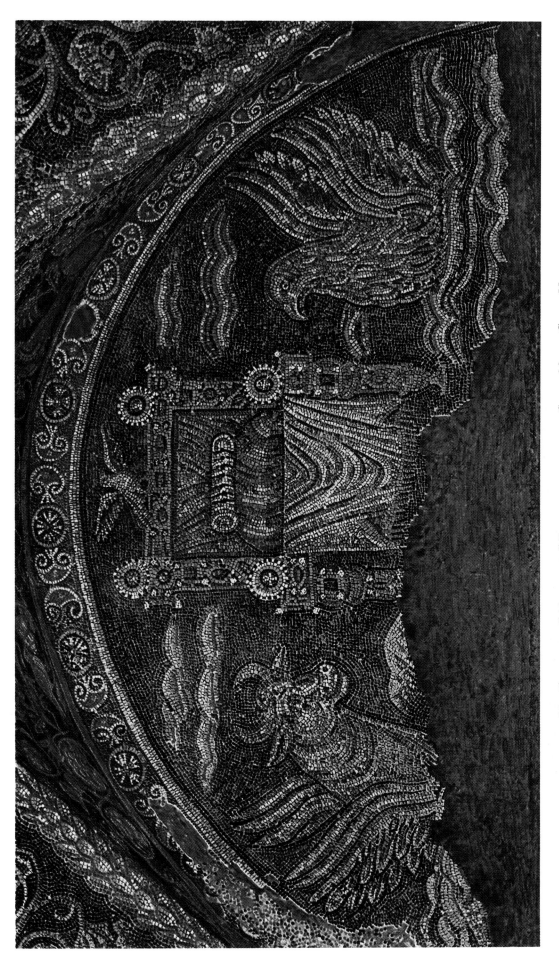

31. CHAPEL OF S MATRONA, S PRISCO, IN VICINITY OF SANTA MARIA CAPUA VETERE
Scroll with seven seals, dove of Holy Ghost on throne, symbols for Saint Luke (bull) and Saint John (eagle)

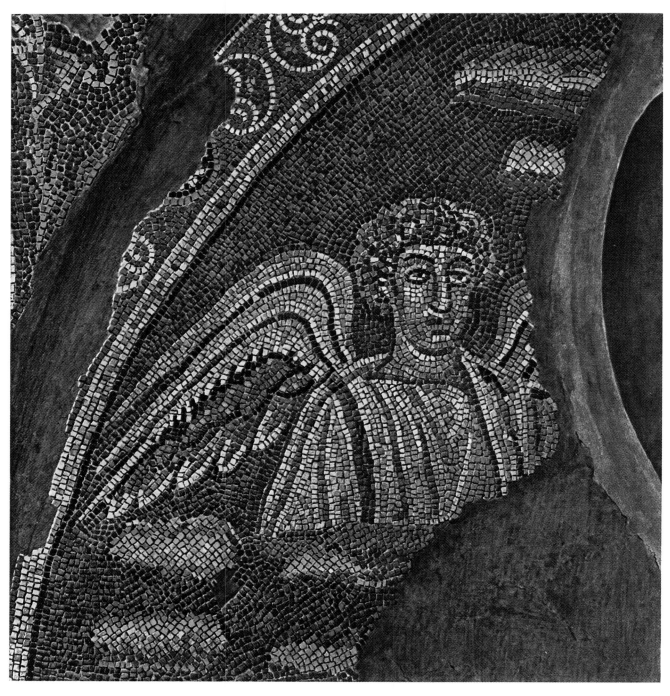

32. Chapel of S Matrona, S Prisco, in vicinity of Santa Maria Capua Vetere
Angel of Saint Matthew

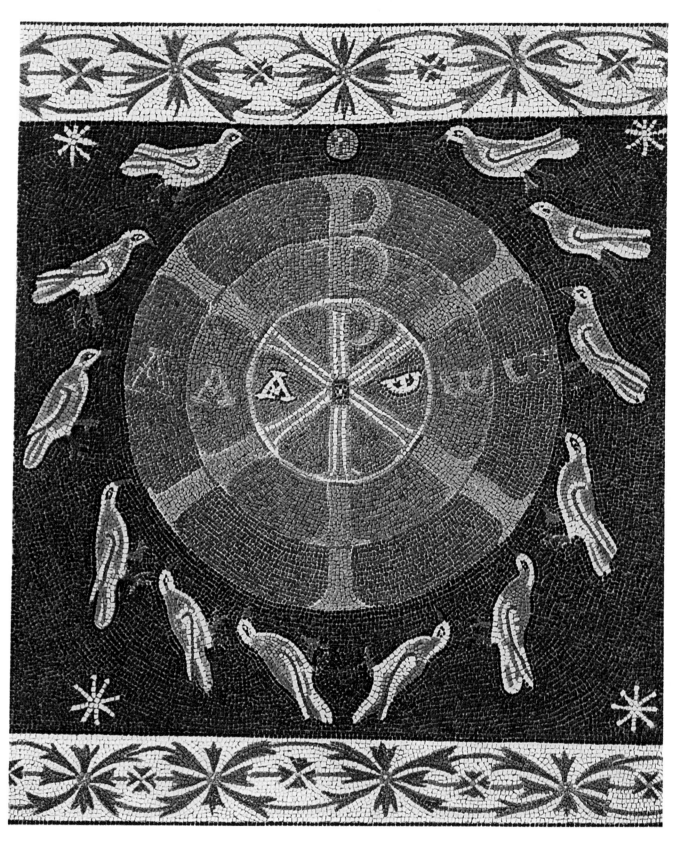

33. BAPTISTERY, ALBENGA
Christogram with twelve doves

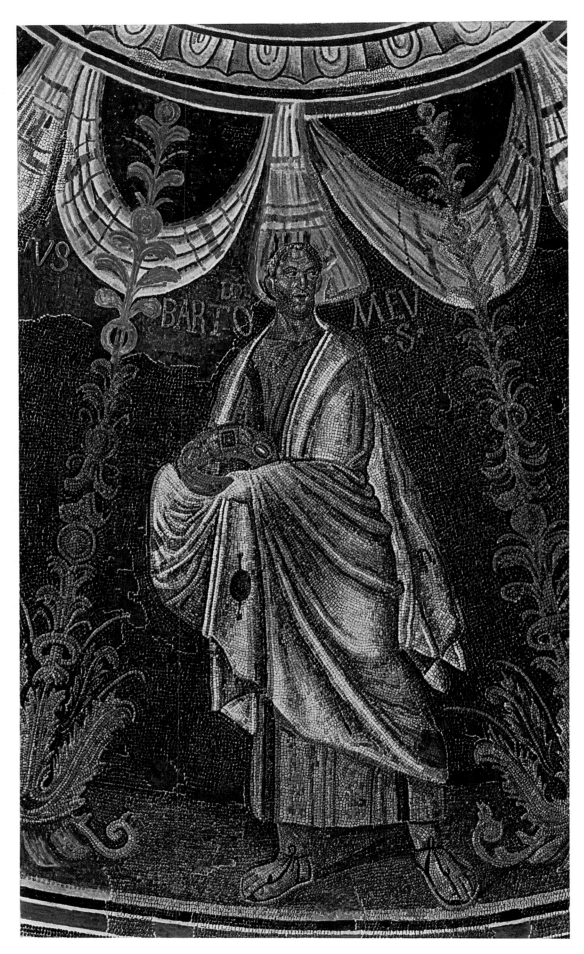

34. ORTHODOX BAPTISTERY, RAVENNA
Apostle Bartholomew

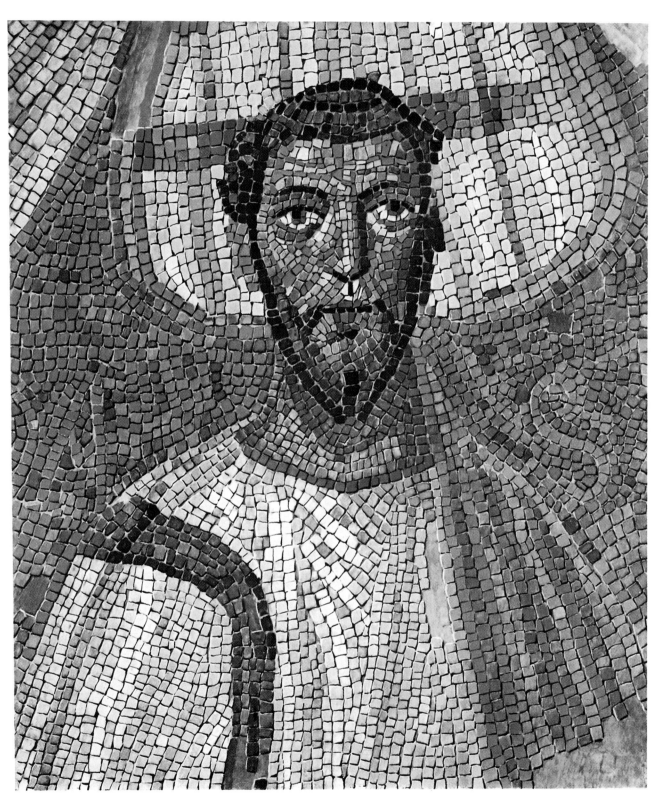

35. ORTHODOX BAPTISTERY, RAVENNA
Apostle Judas the Zealot

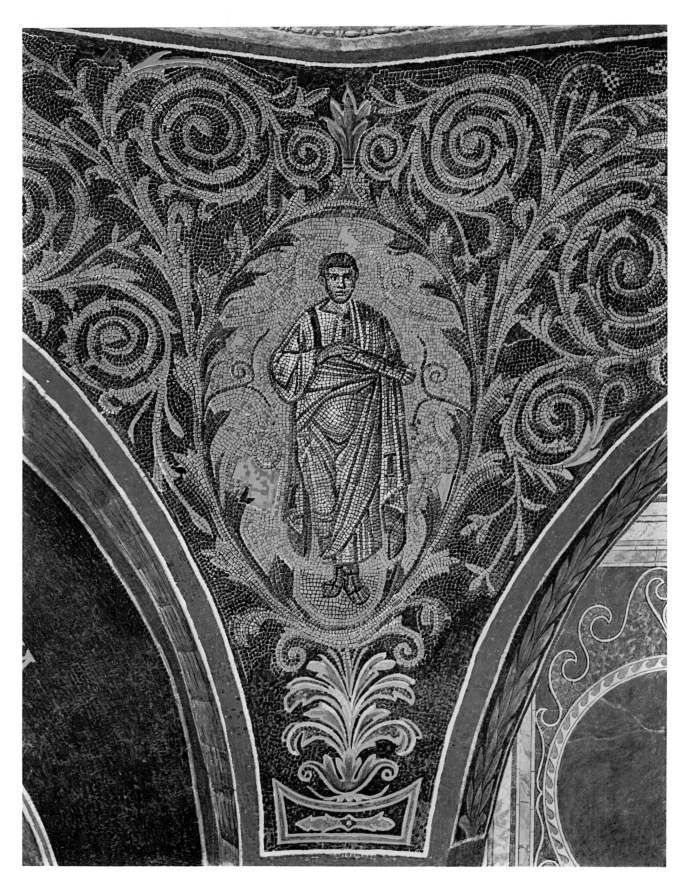

36. ORTHODOX BAPTISTERY, RAVENNA
Prophet among vines

37. ORTHODOX BAPTISTERY, RAVENNA
Throne with royal robes and cross

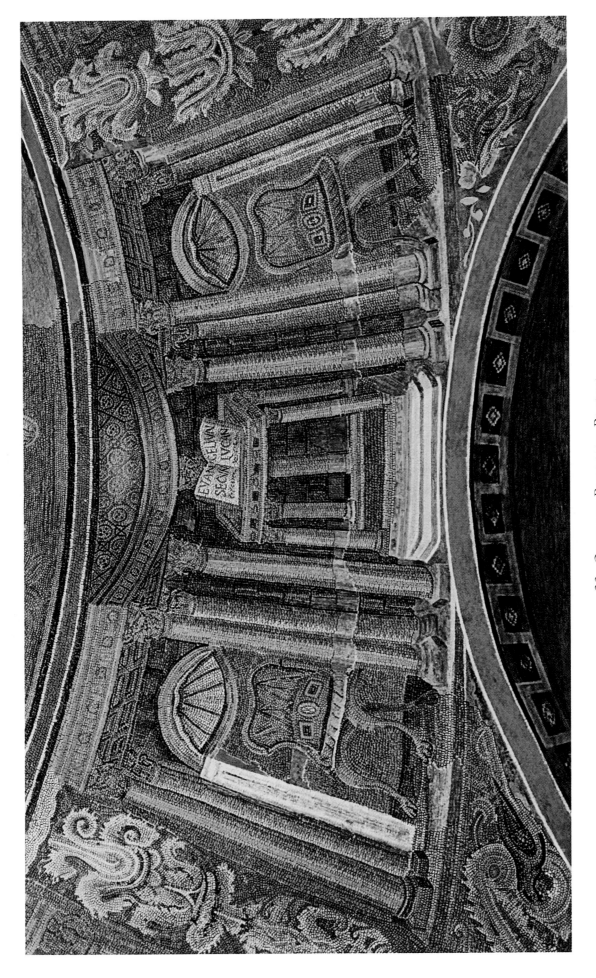

38. ORTHODOX BAPTISTERY, RAVENNA
Altar with book, stands with crowns

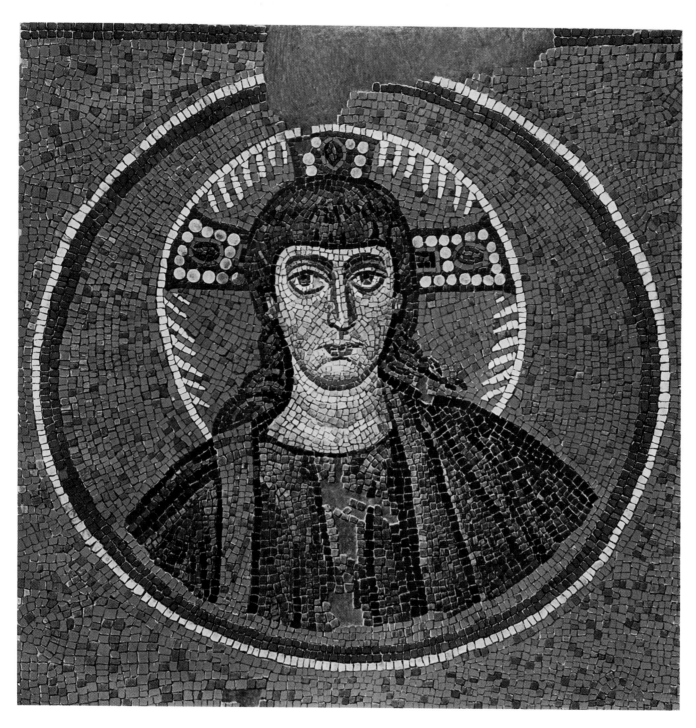

39. Archbishop's Chapel, Ravenna
Portrait of Christ

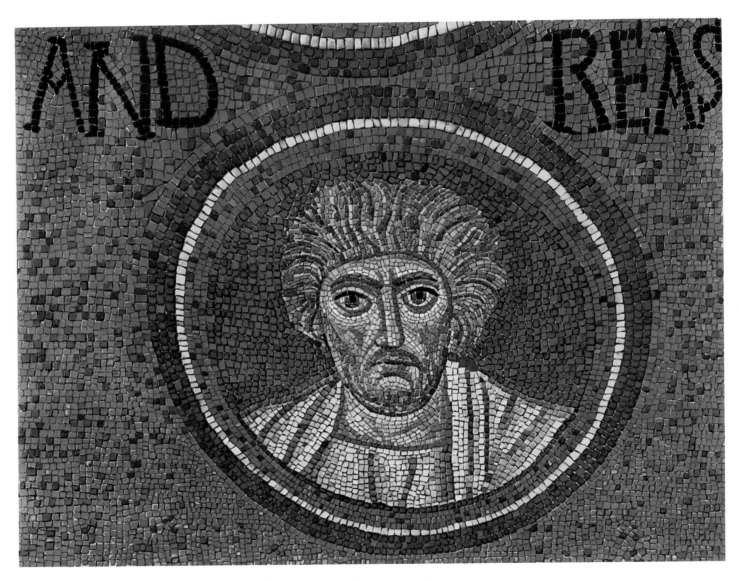

40. ORTHODOX BAPTISTERY, RAVENNA
Apostle Andrew

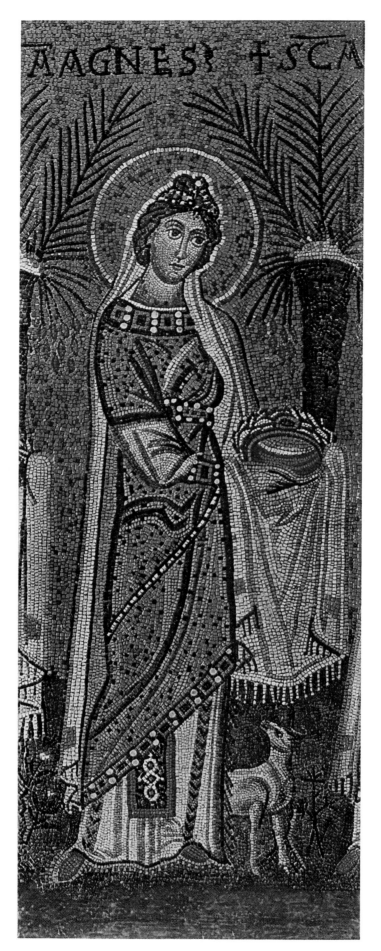

41. S Apollinare Nuovo, Ravenna
St. Agnes

42. S APOLLINARE NUOVO, RAVENNA
Calling the Apostles Peter and Andrew

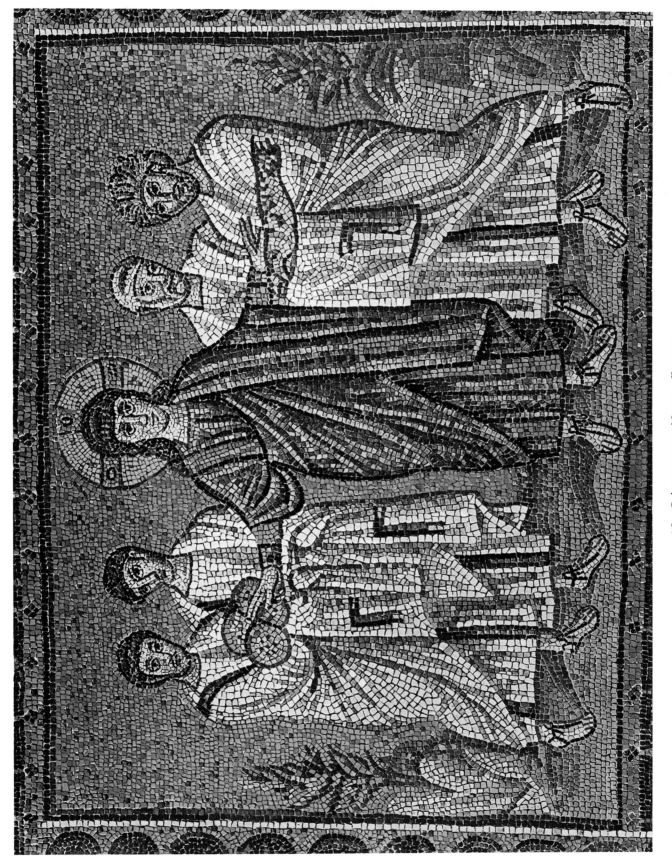

43. S APOLLINARE NUOVO, RAVENNA
Multiplying the loaves and fishes

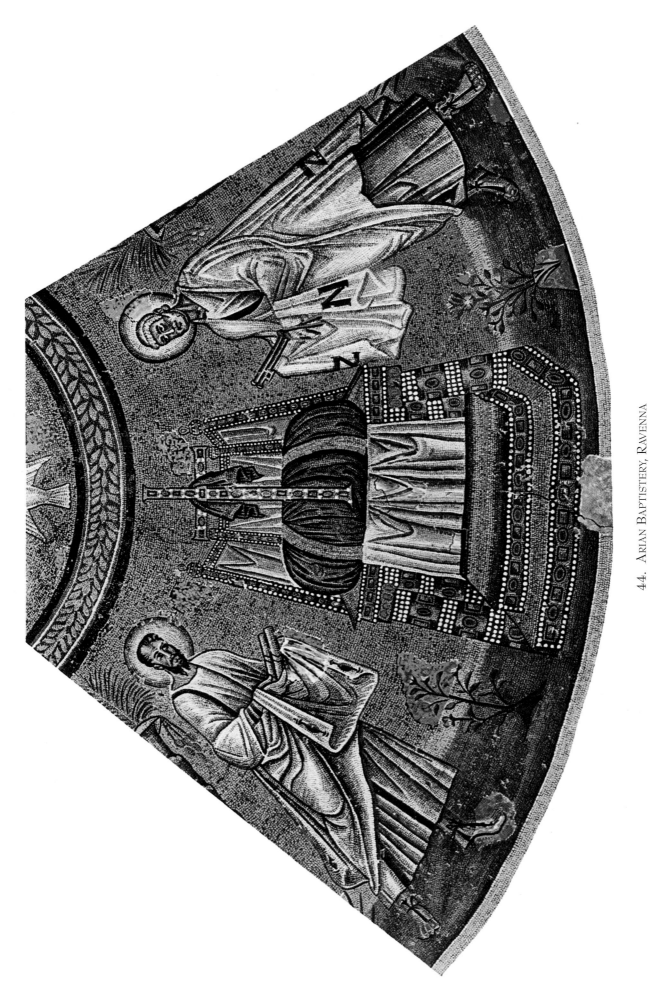

44. ARIAN BAPTISTERY, RAVENNA

Jeweled throne with jeweled cross and purple robe between the Apostles Peter and Paul

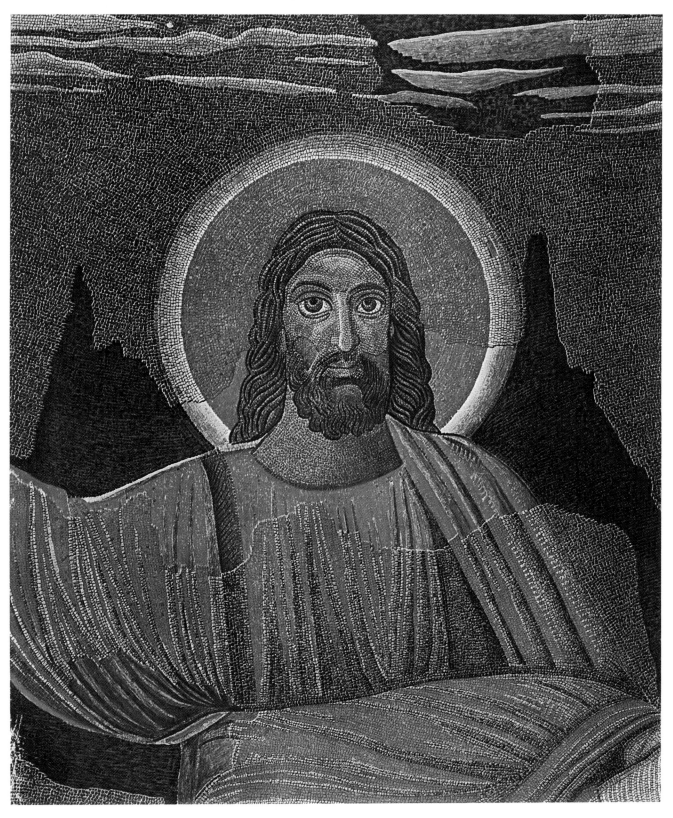

45. SS Cosma and Damiano, Rome
Christ (detail from apse mosaic)

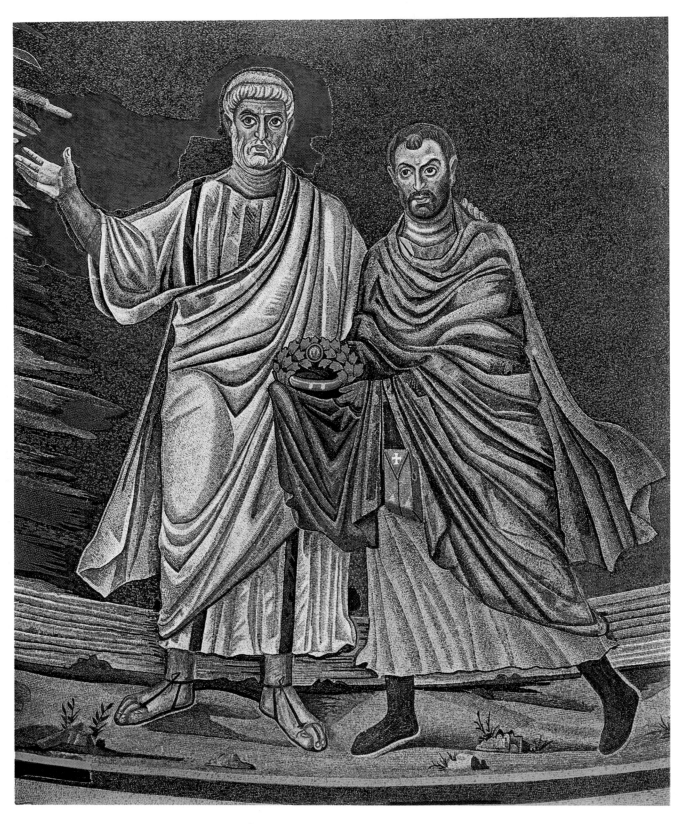

46. SS COSMA AND DAMIANO, ROME
Apostle Peter and Saint Cosmas

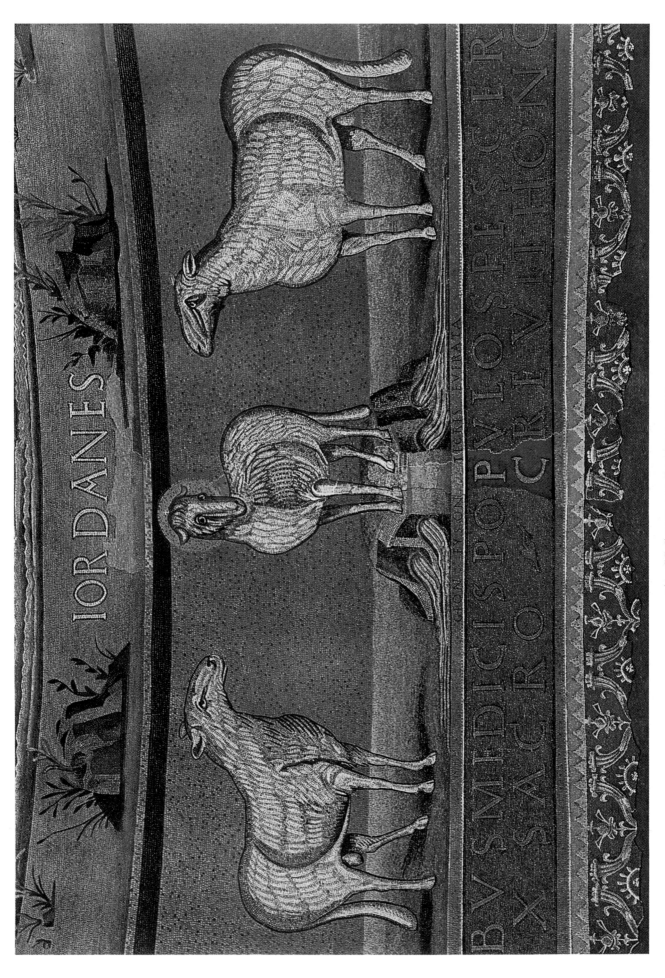

47. SS COSMA AND DAMIANO, ROME
Lamb of God standing on mountain from which flow the four rivers of paradise

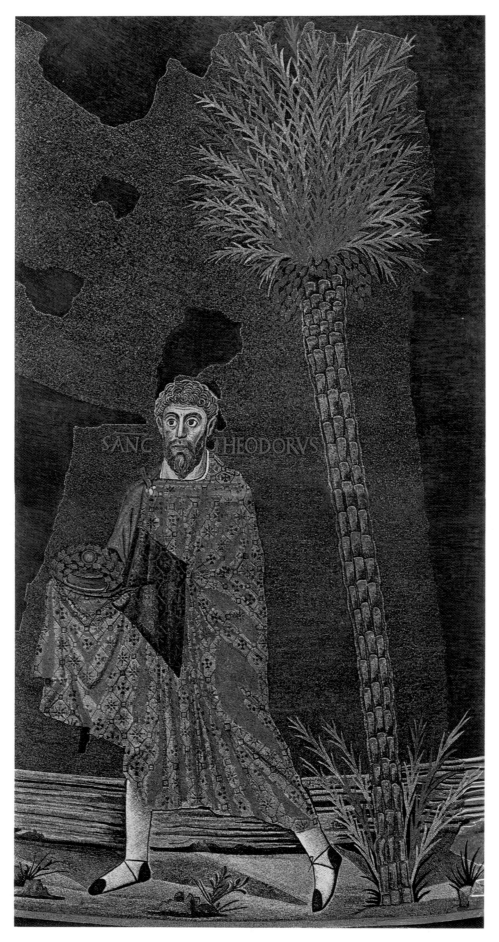

48. SS COSMA AND DAMIANO, ROME
St. Theodore in paradise

49. S VITALE, RAVENNA

Emperor Justinian and Archbishop Maximian and followers

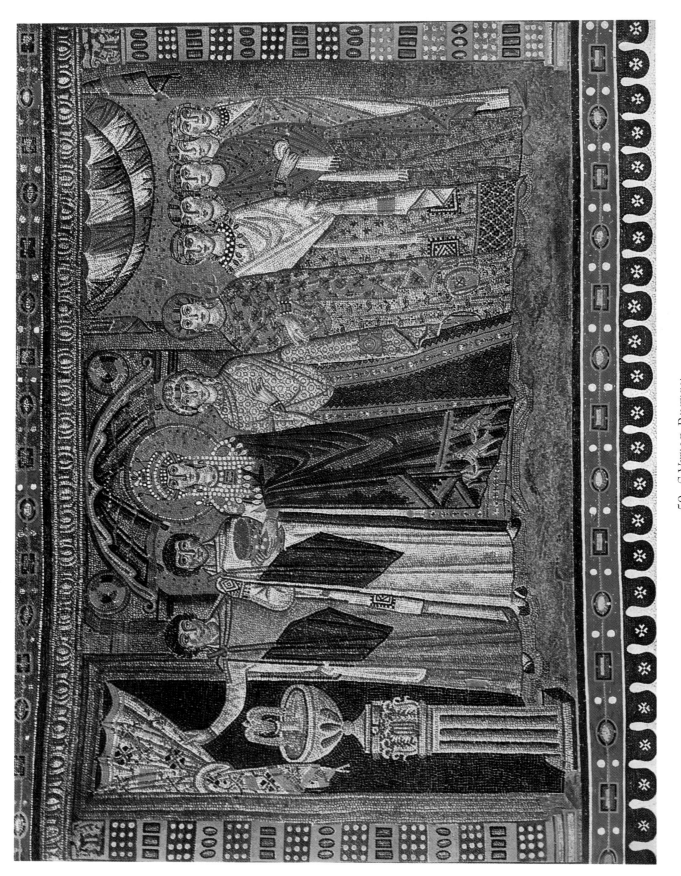

50. S Vitale, Ravenna
Empress Theodora and followers

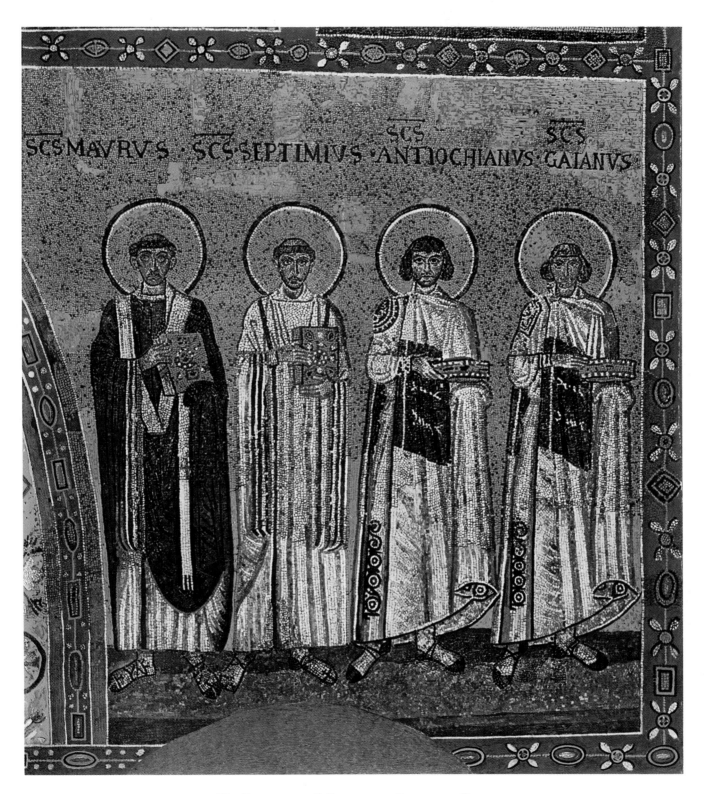

51. Baptistery, S Giovanni in Laterano, Rome
Four martyrs

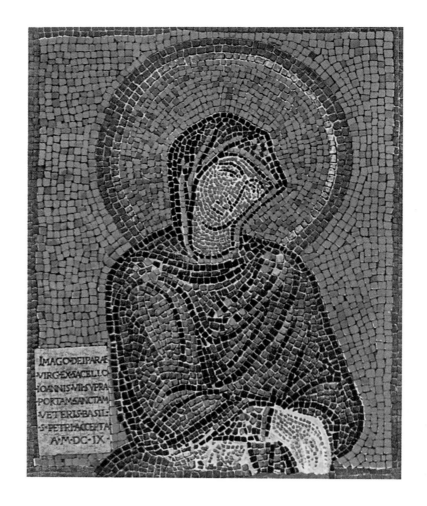

IMAGO·DEIPARÆ
VIRG·EX·SACELLO
IOANNIS·VII·SYPRA
PORTAM·SANCTAM
VETERIS·BASIL·
·S·PETRI·ACCEPTA·
A·M·DC·IX·

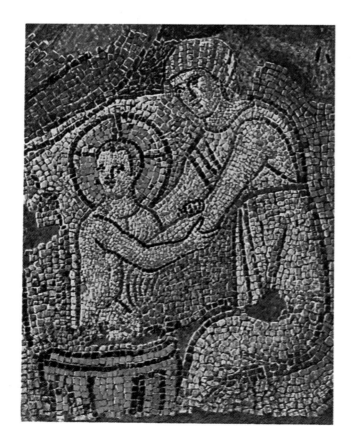

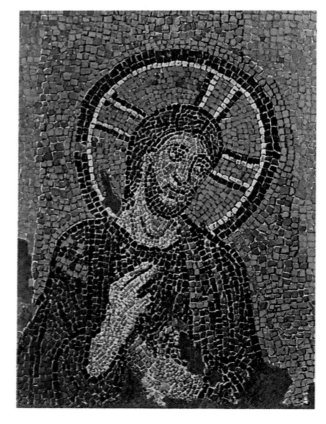

52. OLD ST. PETER'S BASILICA (NO LONGER EXTANT), ROME
Mary (from birth scene); bathing baby Jesus; Christ (from arrival in Jerusalem)

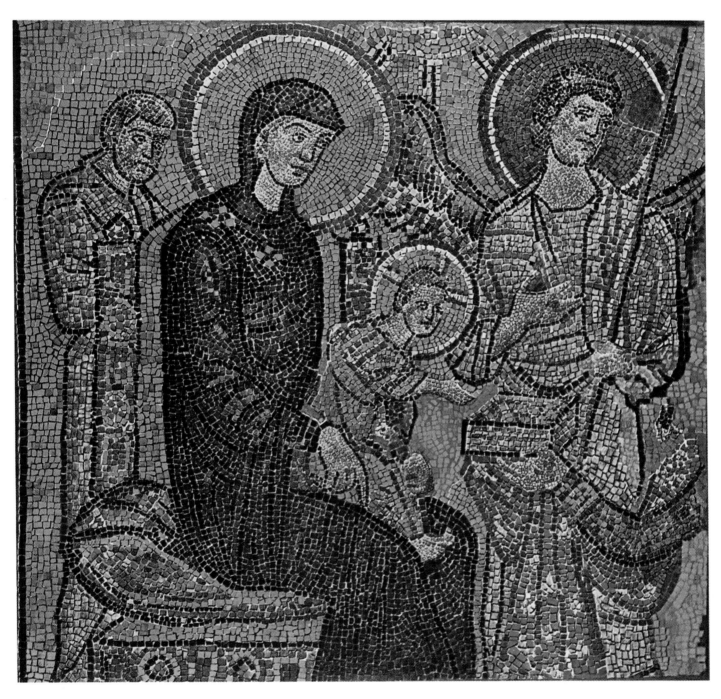

53. Old St. Peter's Basilica (no longer extant), Rome
Adoration of the Magi

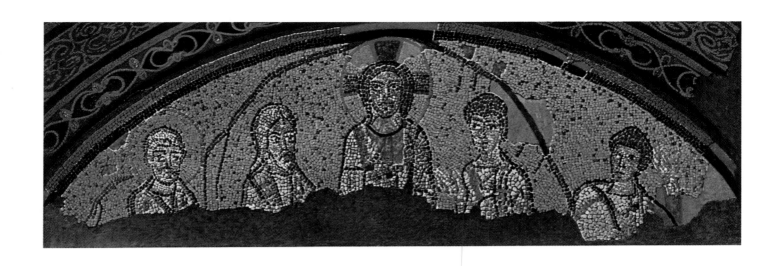

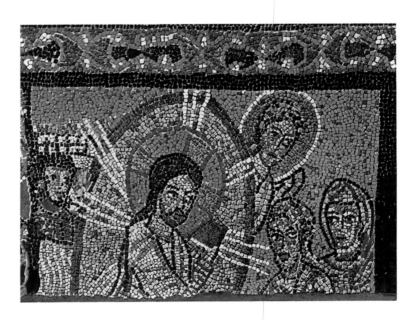

54. S ZENO CHAPEL, S PRASSEDE, ROME
Transfiguration of Christ; descent into Hell

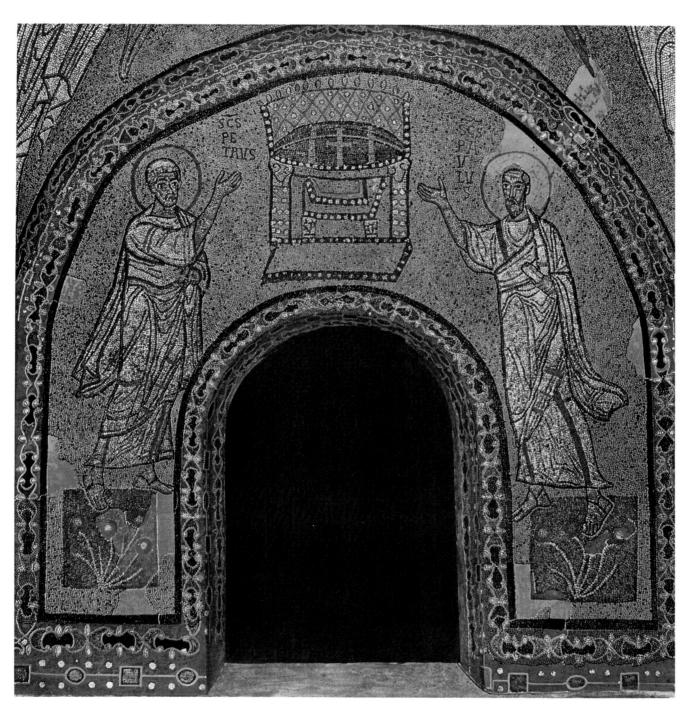

55. S Zeno Chapel, S Prassede, Rome
Cross on throne, with Apostles Peter and Paul

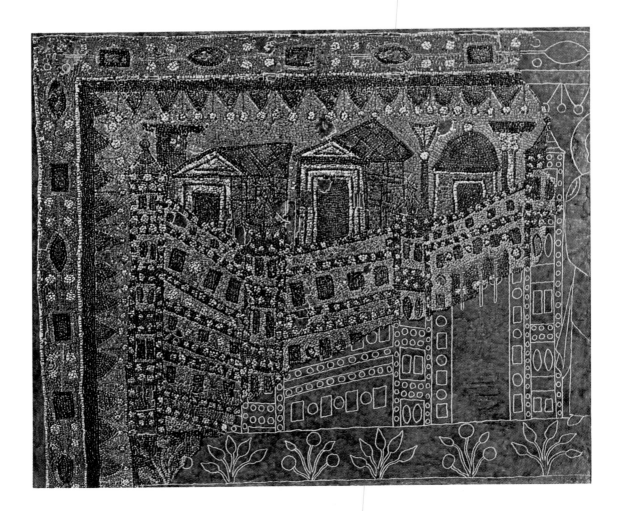

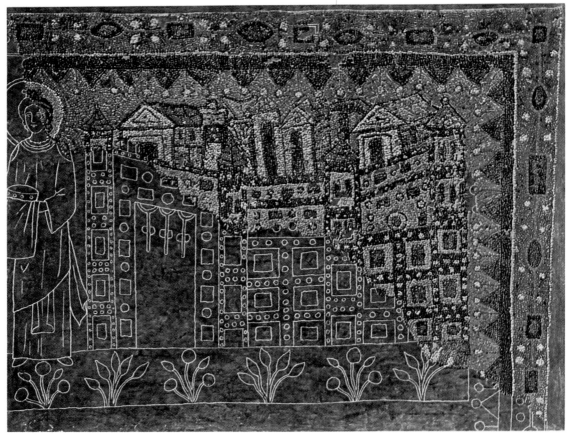

56. S Cecilia in Trastevere, Rome

Heavenly cities

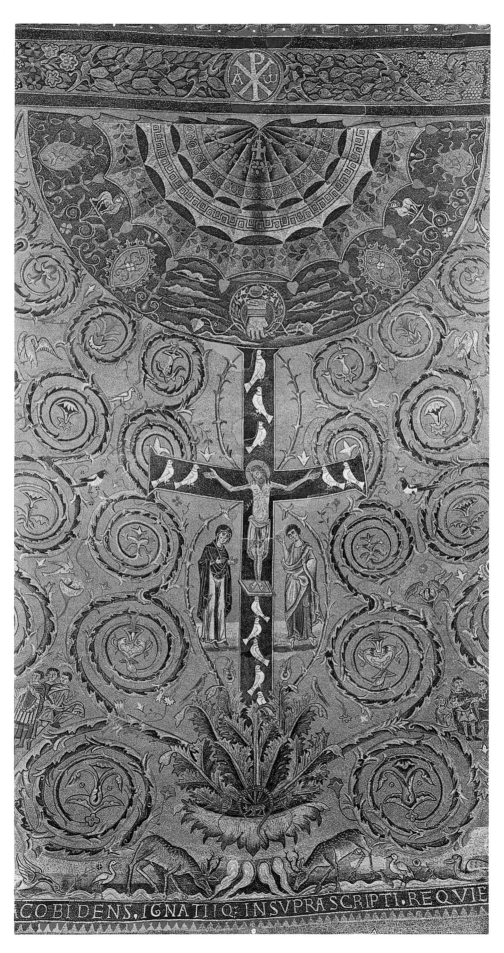

57. S Clemente, Rome

Crucifixion motif among acanthus vines (detail of apse mosaic)

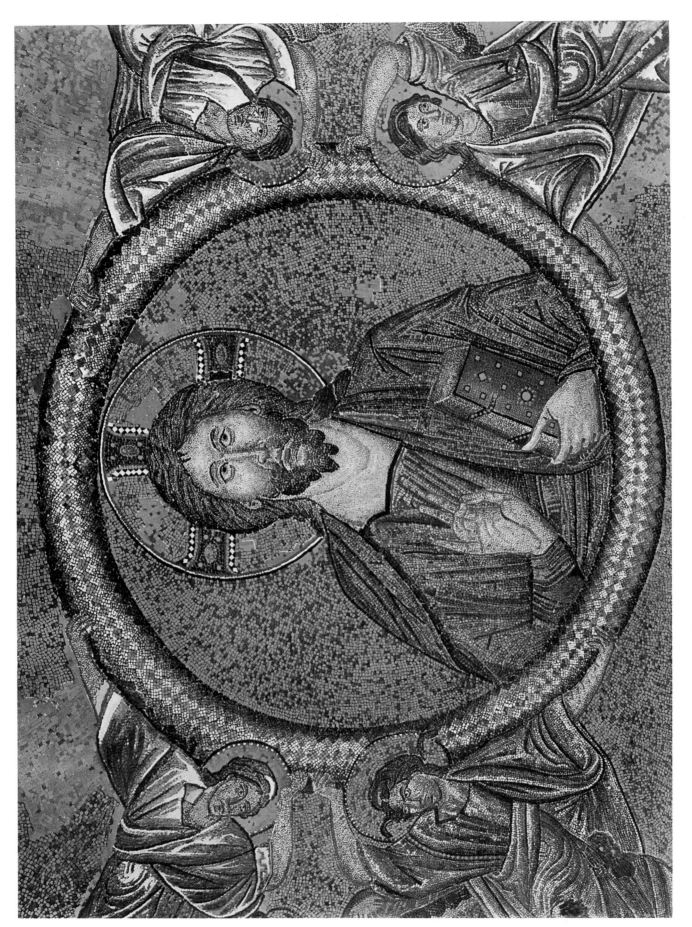

58. Sancta Sanctorum at the Lateran Palace, Rome
Portrait of Jesus, carried by angels

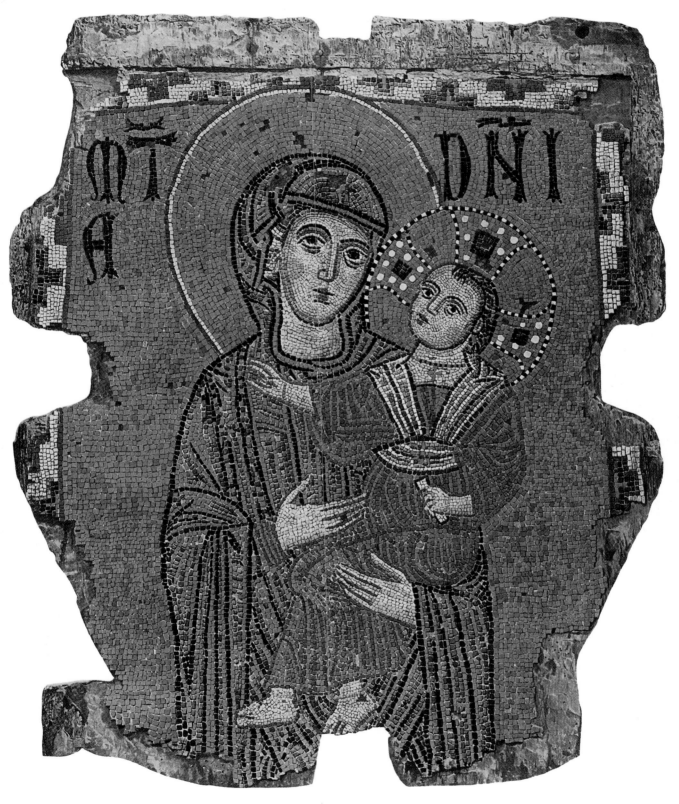

59. BLESSED SACRAMENT CHAPEL, S PAOLO FUORI LE MURA, ROME
Madonna and Child

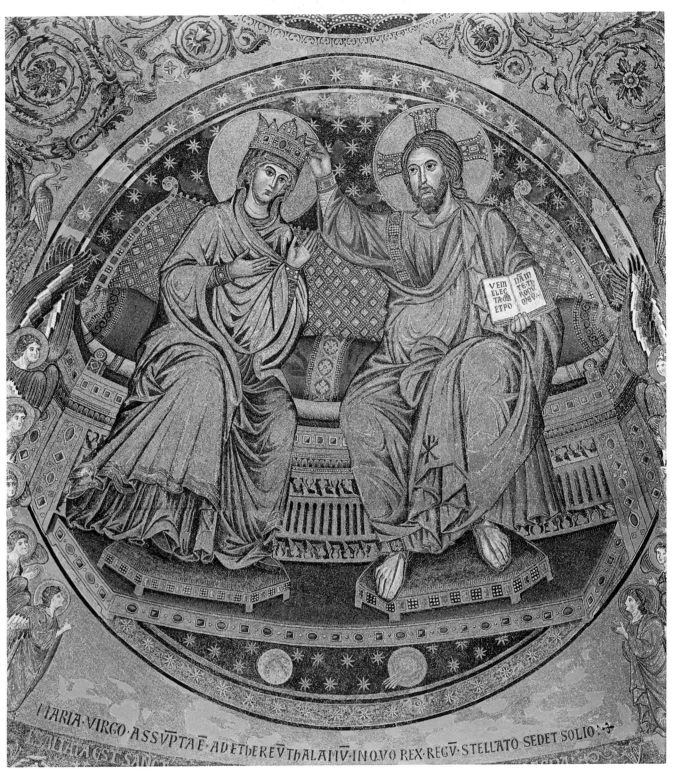

60. S Maria Maggiore, Rome
Coronation of Mary (detail)